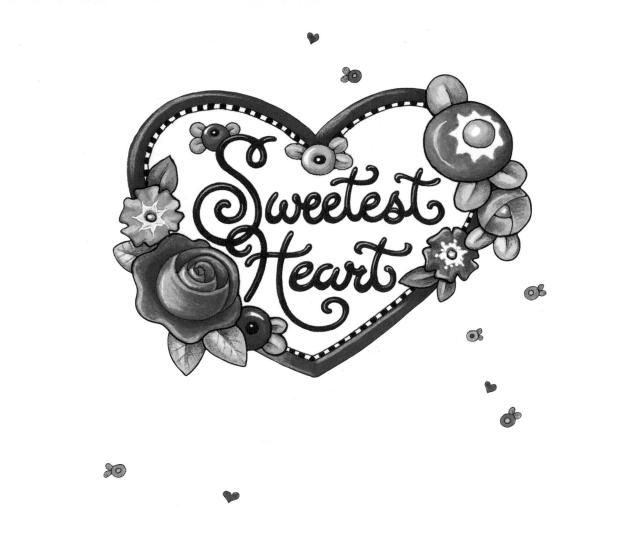

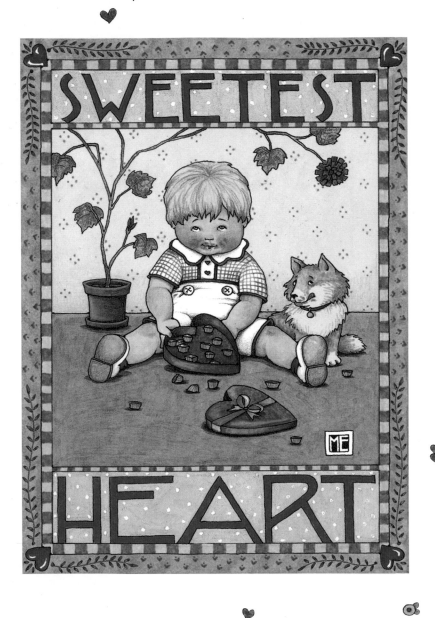

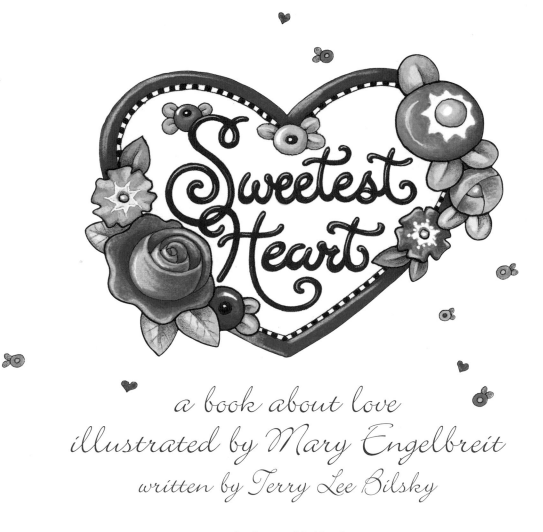

Sweetest Heart

a book about love

illustrated by Mary Engelbreit

written by Terry Lee Bilsky

**Andrews McMeel
Publishing**

Kansas City

is a registered trademark of Mary Engelbreit Enterprises, Inc.

00 01 02 03 04 Mon 10 9 8 7 6 5 4 3 2 1

Engelbreit, Mary.
 Sweetest heart : a book about love / illustrated by Mary Engelbreit ; edited by
Terry Lee Bilsky.
 p. cm.
 ISBN 0-7407-1128-8 (hd slipcase)
 1. Engelbreit, Mary. 2. Love in art. I. Bilsky, Terry Lee. II. Title.
 NC975.5.E54 A4 2000
 741.6′84--dc21

 00-030382

Design by Stephanie R. Farley

ATTENTION: SCHOOLS AND BUSINESSES Andrews McMeel books are avail-
able at quantity discounts with bulk purchase for education, business, or sales pro-
motional use. For information, please write to: Special Sales Department, Andrews
McMeel Publishing, 4520 Main Street, Kansas City, Missouri 64111

Contents

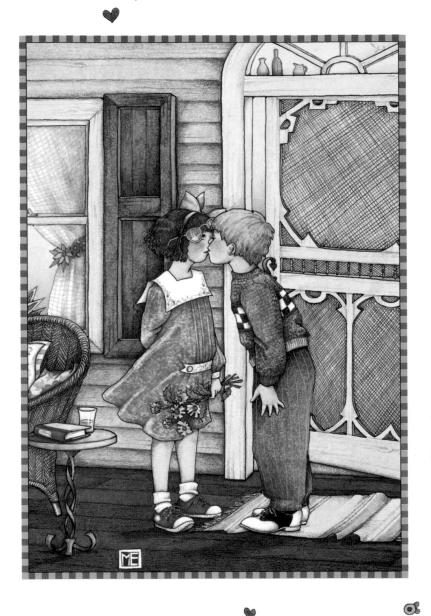

introduction

*M*aybe I saw too many movies when I was growing up but let's face it, I am a secret, hopeless romantic.

From the very first time I picked up a paintbrush, love has been a subject near and dear to the bottom of my heart. I cannot resist the blush of first love, little boys delivering flowers and chocolates, young girls rushing to their mailbox searching for love letters or party invitations. Who doesn't remember their first kiss? Why it's enough to knock a girl's glasses off!

When I stop to really think about it, I cannot remember a time in my life when I wasn't in love. Naturally, I fell in love with my parents first. How could I not? They bestowed on me enough love to last a lifetime.

My parents made me feel special and encouraged the artist in me. I was lucky enough

to share them with my two sisters. Growing up with sisters taught me how to be a friend to others. I think my drawings reflect all that is good in my relationship with my family.

Friendships are the families we create for ourselves. Everyone who is a friend knows how good it feels. The love of a friend helps us through the rough spots and what feels better than to lend a helping hand to someone we love?

Young love, which so many of my valentines reflect, is a state of flutters no one can explain. Everyone remembers the first time they were smitten, whether in kindergarten or college. I remember the boy who first stole my heart. There was no denying the butterflies in my stomach or shortness of breath. Instead of homework, I drew his face and wrote his name endlessly on the edges of my schoolbooks.

How many times does our heart skip a beat before our one true love comes along? How lucky we are to find a soul mate on this earth, a true companion, a partner for life. Everytime I

hear wedding vows, I am remind-
ed of the day I said "I do" to my
own knight in shining armor. My
heart told me he was the one
and I am so glad I listened.

So, because of
these life experi-
ences, I'll draw
my hearts and
flowers, smitten
young girls and
boys, true
friends and lov-
ing families, and
hope that you
find love in
lots of differ-
ent places.

In the following pages, a
true friend of mine, Terry Lee
Bilsky offers her heart-felt
thoughts on my illustrations. As
a writer, she's been inspired by
my drawings, has
contributed to
my magazine and
remains a true
friend.

It's not hard
to find love
all around you,
if you listen to
your heart!

Mary

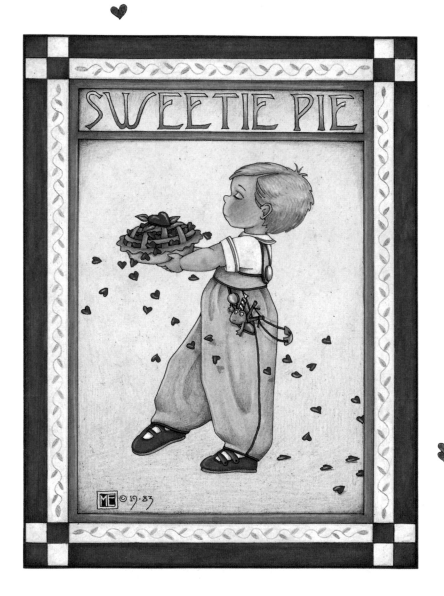

sweetie pie

Mary Engelbreit's drawings bring us back to a time of wearing charm bracelets linked with hearts, wilting away the hours daydreaming "he loves me, he loves me not."

Ah, the good old days when the fate of his feelings were determined by petals on a flower. And who can forget their first dance? Do you remember getting dressed up and putting on your charm bracelet so you could watch it sparkle on the shoulder of your dance partner? The boys led the way, sort of, while the girls tried very hard not to step on their toes. All those years of playing your favorite music and practicing with girlfriends and still, you felt your palms beginning to sweat. Or maybe it was because

his palms were sweating!

Did your date bring you a corsage of pink sweetheart roses which you carefully pinned to the collar of your neatly pressed party dress? Girls loved to sneak a bit of mom's special perfume for such evenings. The hint of mom mixed with the sweet scent of roses carried them through the evening.

Tiptoeing into your home hours later, there was bound to be a sister or brother waiting for a full report on the evening's activities. "How was the dance? Did he kiss you? Tell us, tell us, please!" And for how many years have we all kept roses pressed in a scrapbook next to pictures taken at the dance?

I do not know exactly what moment it is when love is learned but there is something so special about children opening their hearts to one another. When our children are young, we can feel it in the form of hugs and wet

kisses on our cheeks. There is a special look in their eyes when they surprise you with flowers picked from the garden or drawings and love notes made especially for you. When it is time to change the artwork on the refrigerator, try putting it in a scrapbook. One day, when they are teenagers and tend to deliver fewer love notes, it will give you something special to curl up with and remember those days.

There is so much to be learned from children and their ability to express their feelings. Take a look around and you will find love in the faces of little ones playing in groups at a very young age. Watch them holding hands, chasing each other and sharing their toys and treats. Before you know it, they are putting on their party clothes and getting ready for their first dance.

It's uncanny how Mary's illustrations capture those universal moments—it's why the world looks to her art and says, "Ah, that's exactly what it's like!"

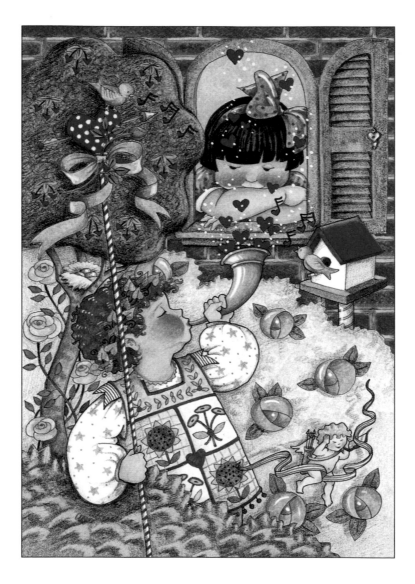

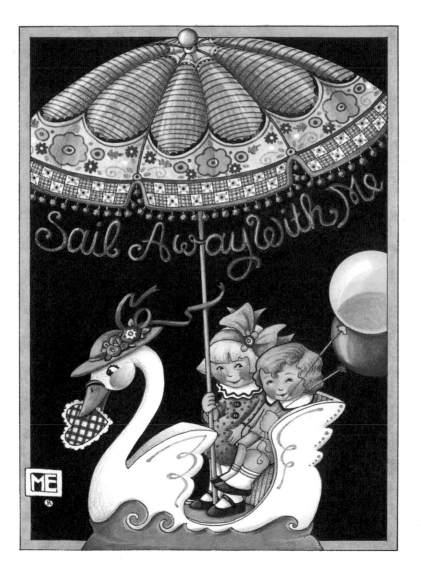

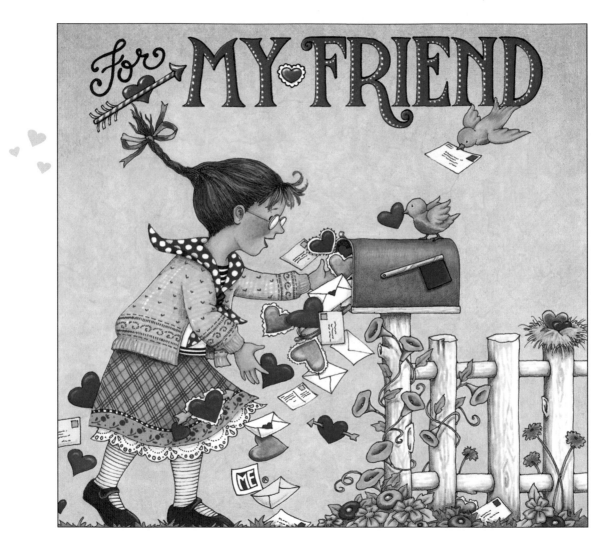

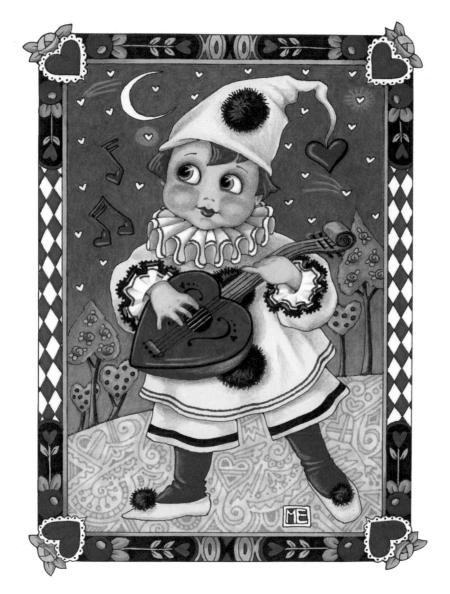

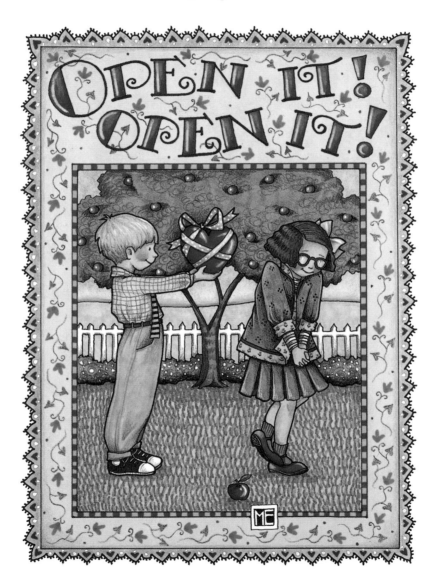

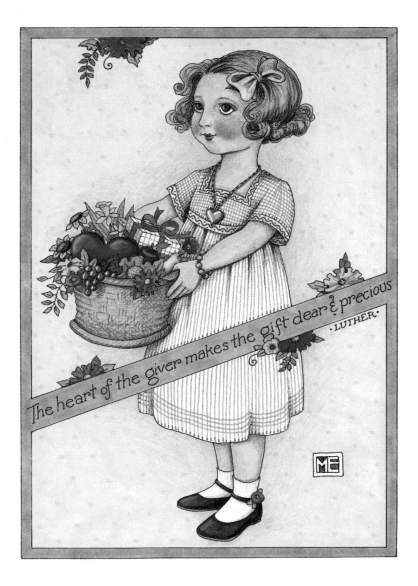

The heart of the giver makes the gift dear & precious ·LUTHER·

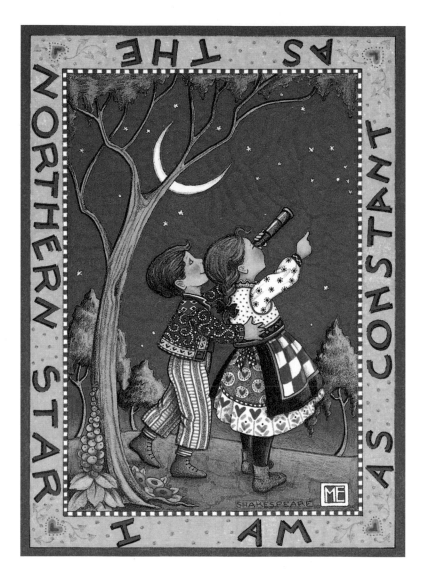

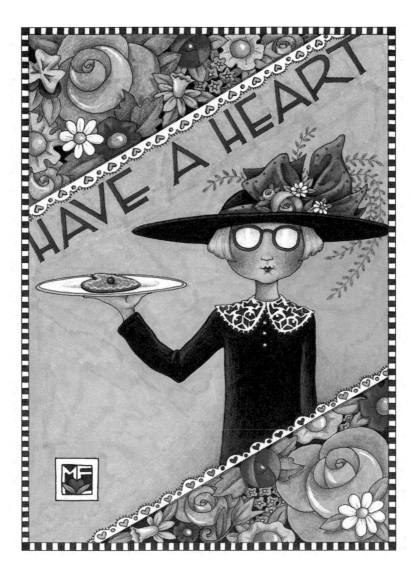

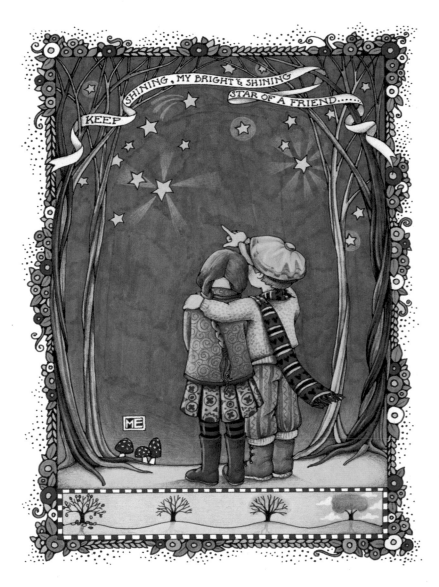

KEEP SHINING, MY BRIGHT & SHINING STAR OF A FRIEND...

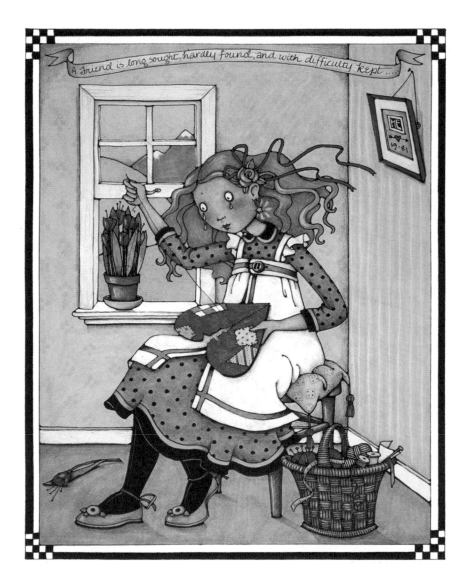

A Friend is long sought, hardly found, and with difficulty kept...

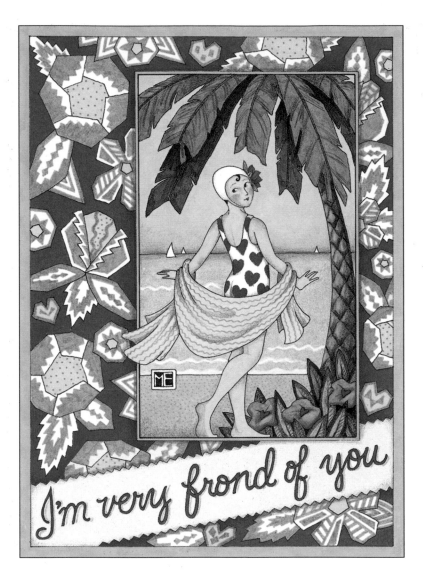

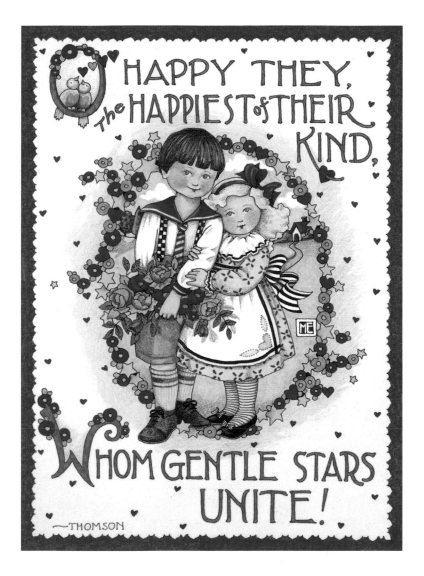

O HAPPY THEY,
The HAPPIEST of THEIR KIND,
WHOM GENTLE STARS UNITE!

—THOMSON

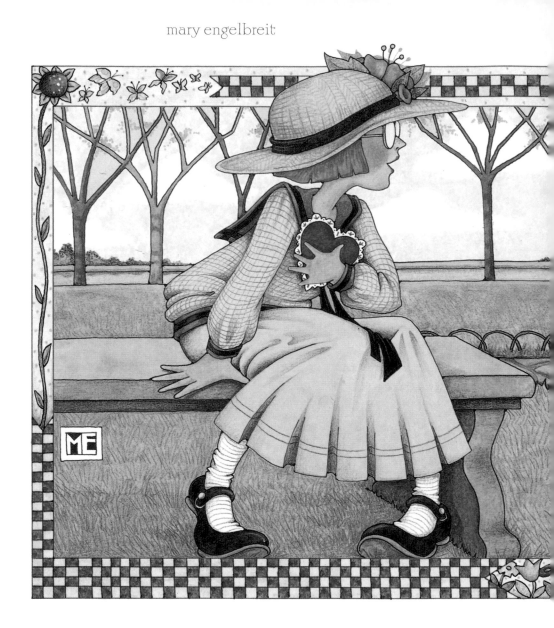

Love is finding
the familiar dear.
"In love"
is to be taken
by surprise.

—Mona Van Duyn

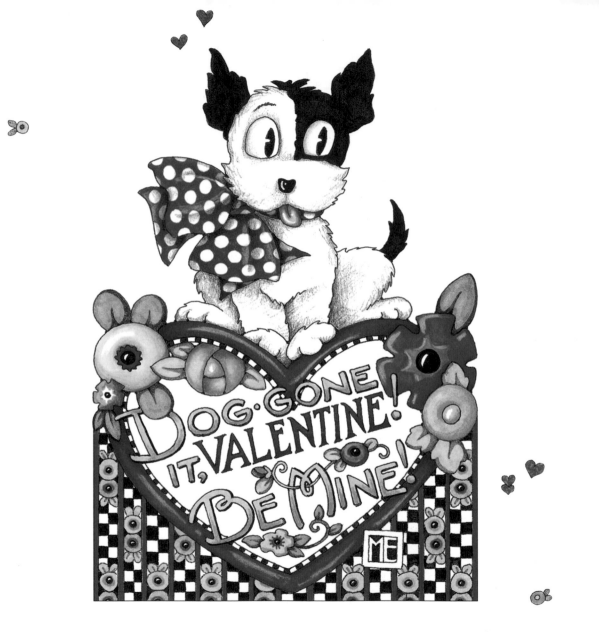

be mine

Valentine's Day wakes us up from a long winter's nap in time to say "Be Mine" to those we love. It reminds us of rosy cheeks, snow-frosted mittens, and hot chocolate beckoning when we come in from the cold.

It's the time of the year when children are anxious to rush indoors even if it is a snow day. When their fingers thaw, it is time to grab their crayons and gather at the kitchen table to get to work on their valentines. Paper doilies, pinking sheers, scissors, red construction paper and white paste are all passed around the table, and, if they are lucky, so are heart-shaped cookies. In between bites of cookies and sips of hot chocolate, they cut and paste, sketch and color, shar-

CUP OF KINDNESS

I ♥ U

ing their love with friends and family. Some make special cut-out hearts to string along the mantel, decorating one for each other as well as their mom and dad, grandparents and even their pets. Depending on how many of their goldfish are alive, they can fill many, many garlands. But just like the snowflakes falling outside their window, no two valentines are alike.

Valentine's Day was absolutely one of our favorite days of the year to celebrate in school. In the front of every classroom was a large mail box, gift-wrapped in red shiny paper with an opening on top. The girls liked to say that their valentines were distinctive since many of them had lacy borders full of cut-out hearts. They could not wait until it was time to deliver the mail. "Pick me, pick me!" they pleaded to their

teacher waving their hands high in the air.

We loved spreading valentines across our desks, guessing who each one might be from before opening it. We pored over every envelope, turning it over to see if "S.W.A.K." appeared on the back.

For that certain someone in class who made our young hearts go pitter-patter, we'd sneak in a pink candy heart or two, inscribed "Sweetheart" or "Be Mine." But never ones to tip our hands, we were sure to sign "from your secret love."

So many years later and still Valentine's Day remains an important day on our calendars. We always meet our girlfriends for lunch so we can exchange our Valentines over tea and a heart-shaped dessert. Try doing the same next year. Stay and linger over a second cup of kindness and then hurry home to check your mailbox. Will there be flowers and chocolates waiting for you? We sure hope so!

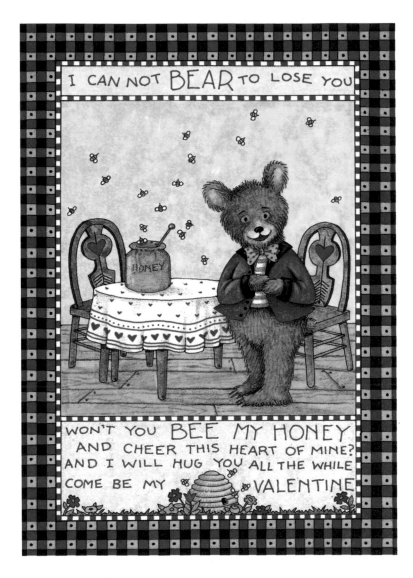

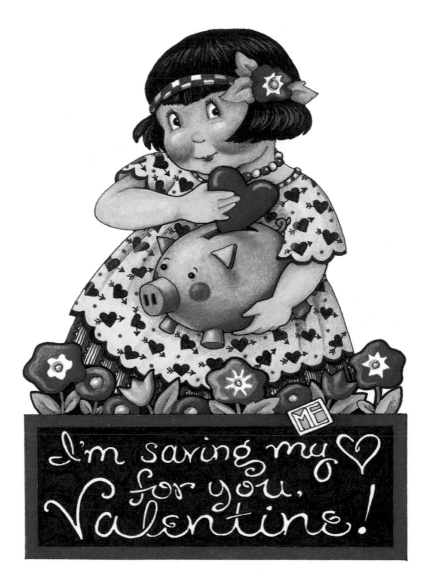

I'm saving my ♡ for you, Valentine!

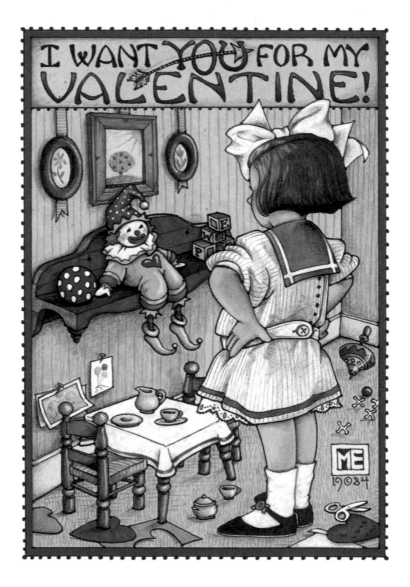

FROM YOUR

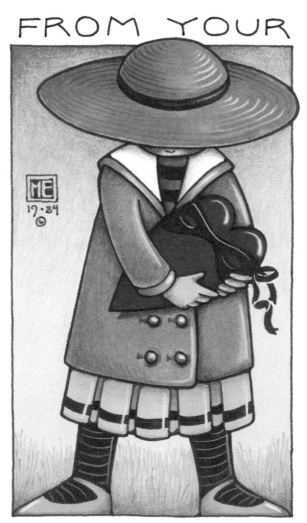

SECRET LOVE

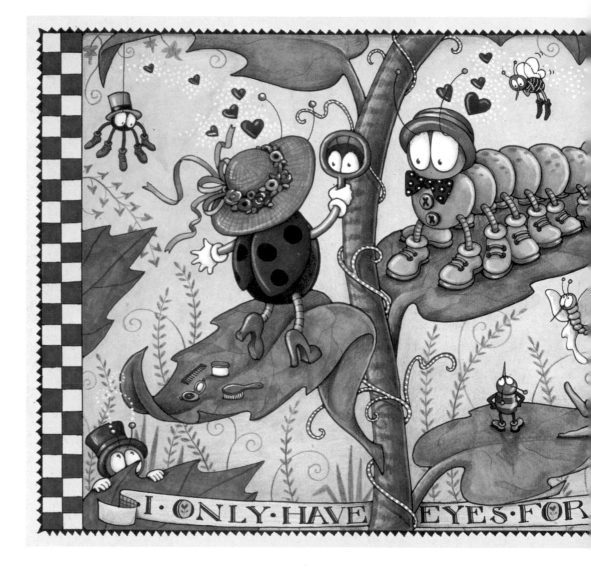

Night and day you are the one,
Only you beneath the moon
and under the sun.

—Cole Porter

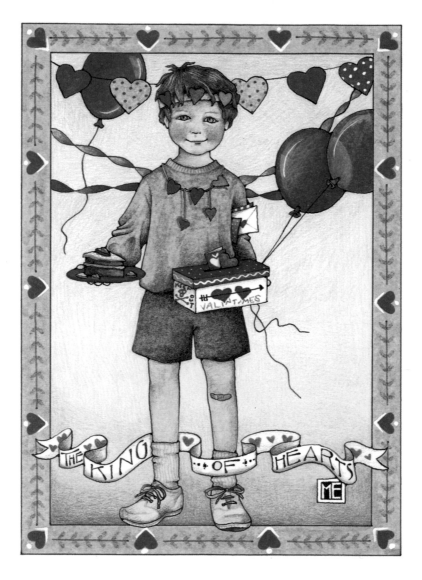

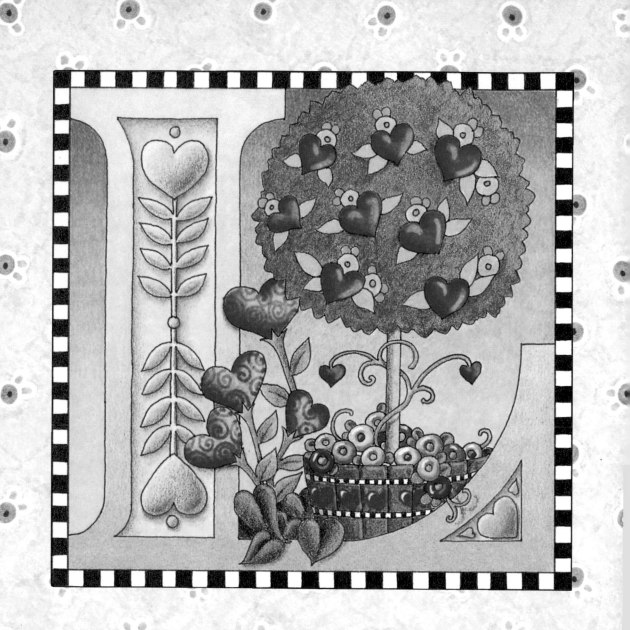

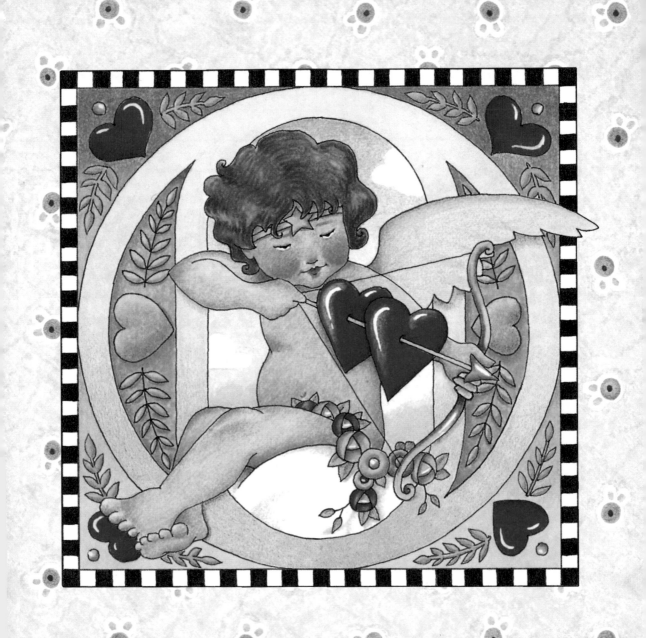

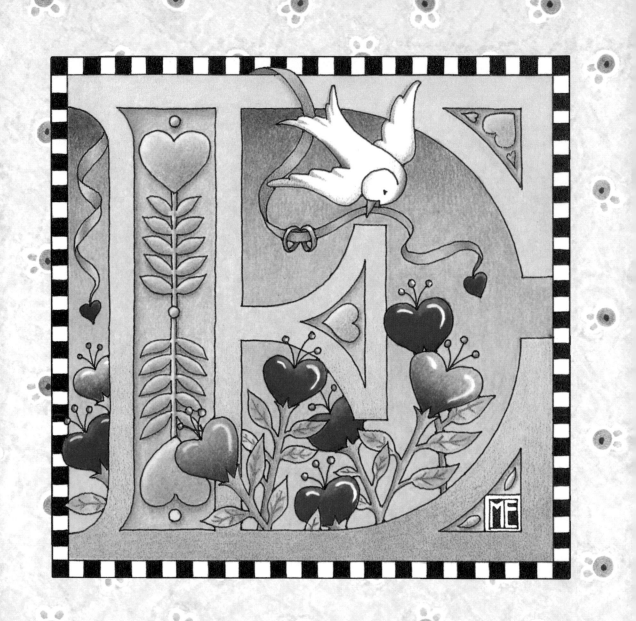

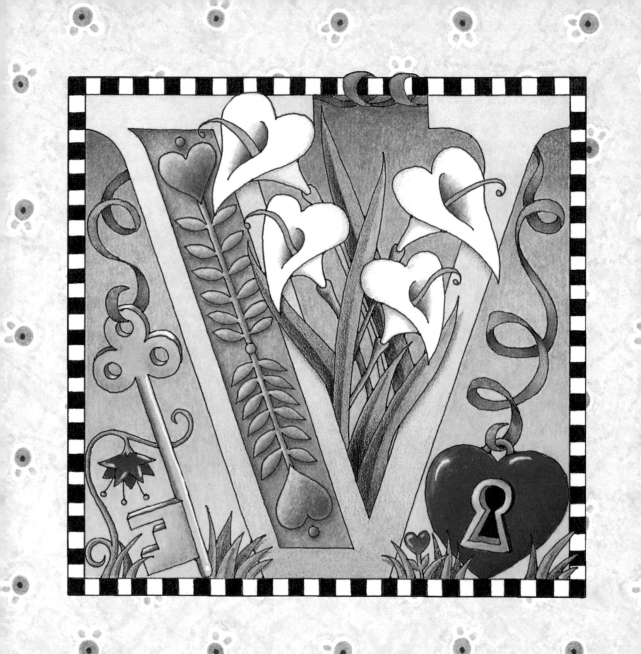

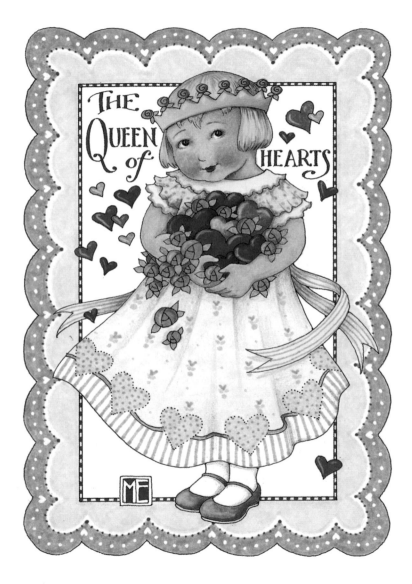

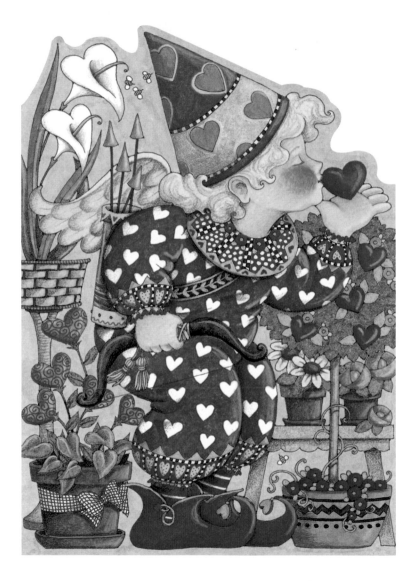

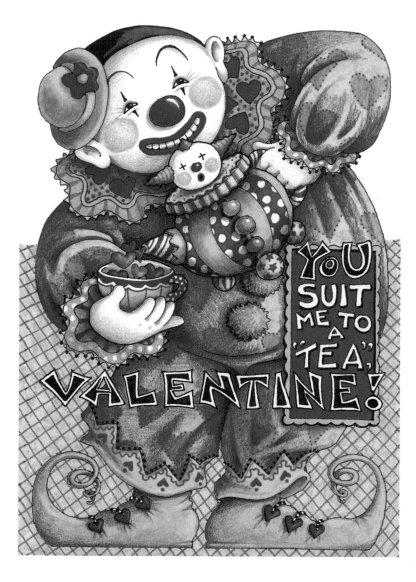

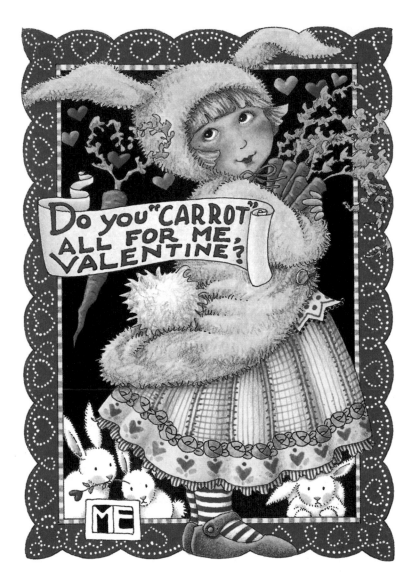

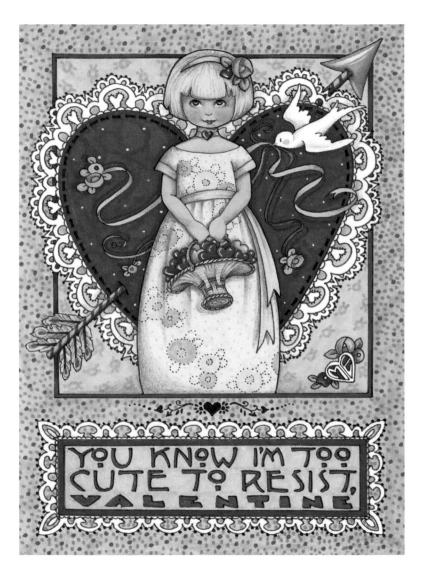

YOU KNOW I'M TOO CUTE TO RESIST, VALENTINE

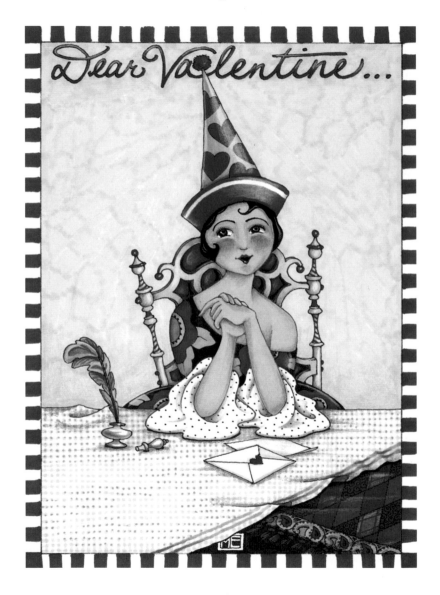

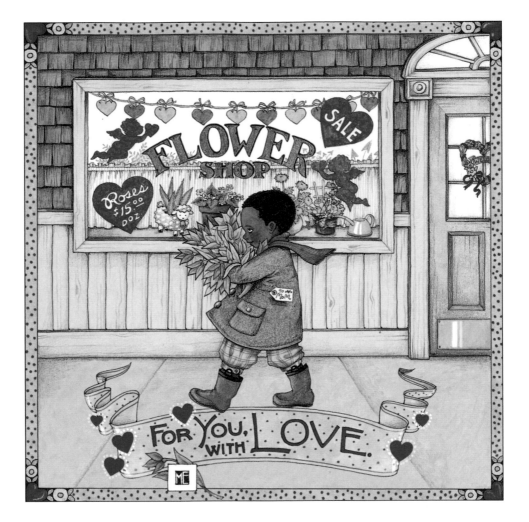

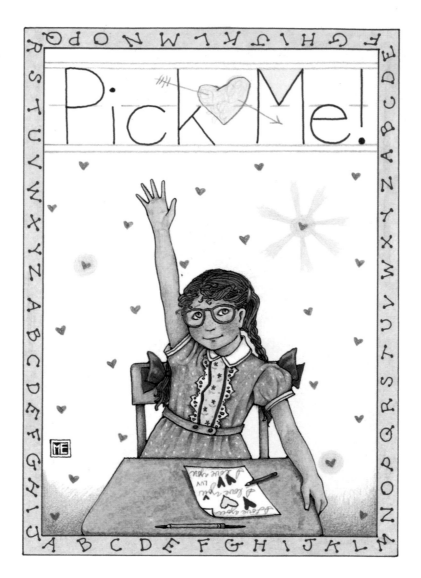

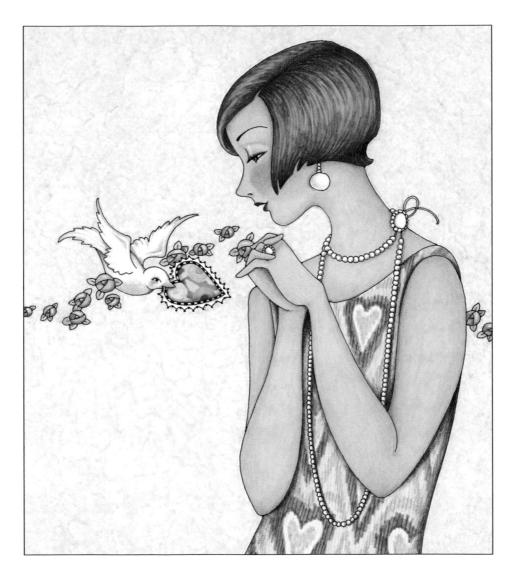

TRUE

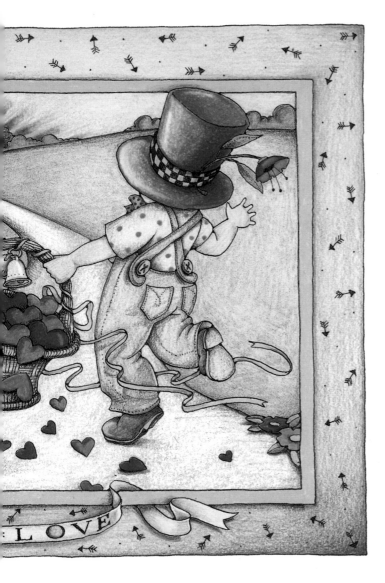

When you love
someone
all your
saved-up wishes
start coming out.

—Elizabeth Bowen

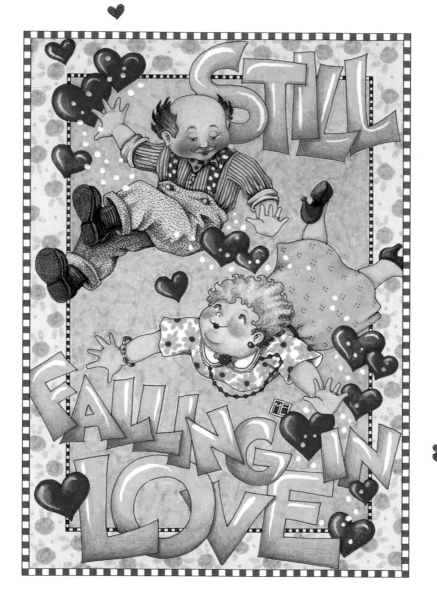

still falling in love

*I*t must be date night. Do you ever find yourself getting all dressed up to spend an evening with the same man you have loved for oh so many years?

No kids, no phones, no guests, just the two of you together. It's your time to be alone. Remember the promise you made years ago to keep dating, even though you are married and have been for some time? It's one of your ways of still falling in love with each other.

Our favorite kind of people-watching is to look at others in love. Often it's the little things to look for like holding hands, walking arm in arm, exchanging glances, or noticing how much two people have to say to each other.

We often wish we could join the couples in Mary Engelbreit's illustrations: Whether it is for a turn on the dance floor or a chance to fill a spare rocking chair on the front porch on a summer evening. Is that asking too much? Mary's images make washing the dishes together look like fun!

Do you remember watching your parents dance together when you were young? There you were, seated at the "kid's table," wishing you could join all the fun at the "grown-up table." There is nothing quite like observing a party from a child's perspective. Suddenly, the same parents you see sipping tea in their bathrobes become very glamorous dancing to their favorite music.

For those of us who grew up with parents who listened

TRUE LOVE

to Cole Porter's music, when you hear "Night and Day," you can visualize candle-light dinners, champagne toasts, guests arriving all dressed up, and trays of hors d'oeuvres ready to be served. No doubt there are children hiding in the kitchen floating cherries in their ginger ale or sitting on top of the stair-case wishing they were older.

It's time to find your charm bracelet and watch how much it still glows. As for your dance partner, you no longer need to worry about sweaty palms or stepping on his toes. Celebrate the love you share for each other.

Love is the answer and it comes in all ages and stages of life and from unexpect-ed places, too. Falling in love can happen at any time of your life, often when you least expect it. The key is to be open to the moment, to allow yourself to be rejuvenated and reborn, and to recognize that a case of the flutters can occur at any time. Shall we dance?

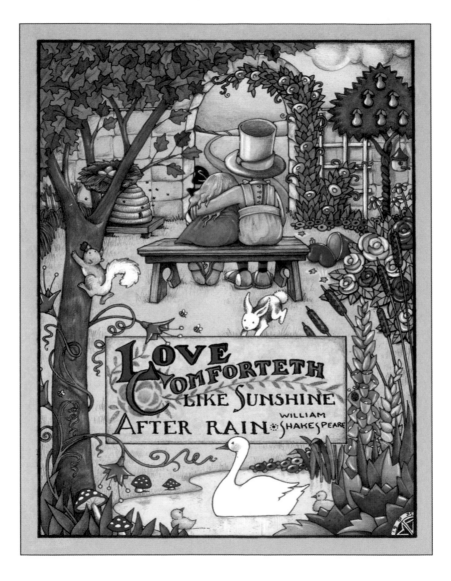

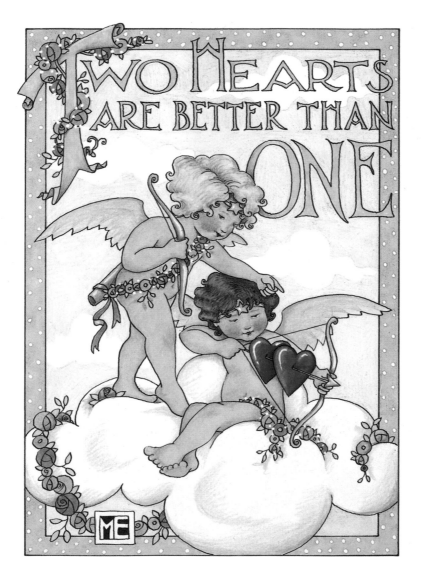

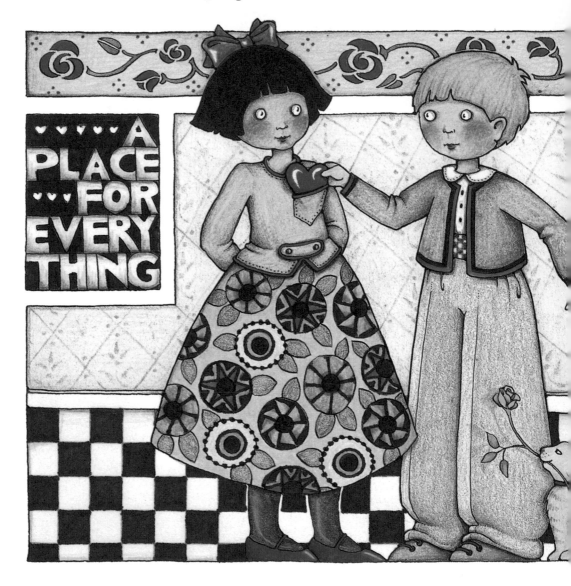

A PLACE FOR EVERY THING

Whatever our souls
are made of,
his and mine
are the same.

—Emily Brontë

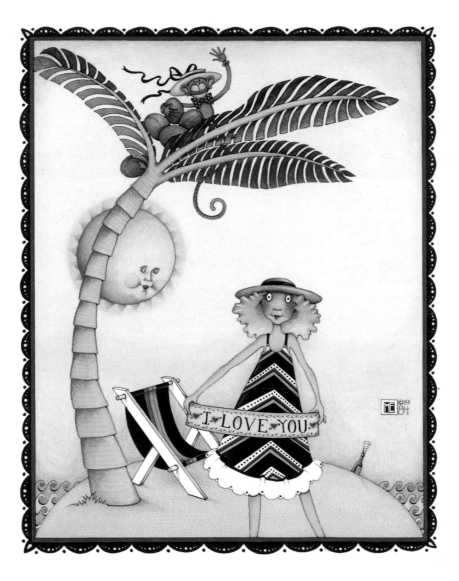

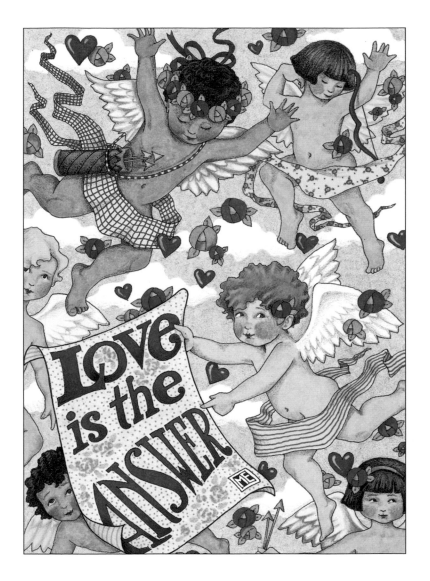

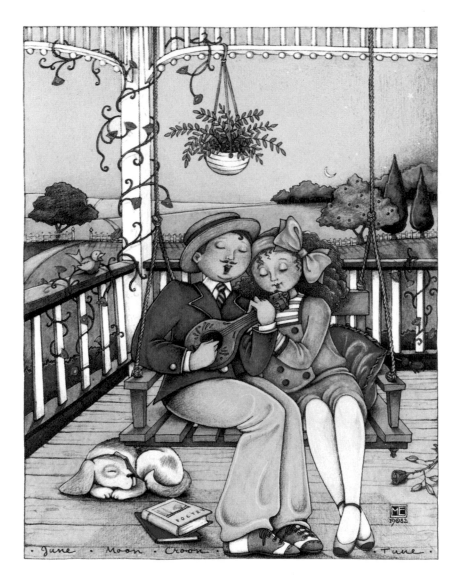

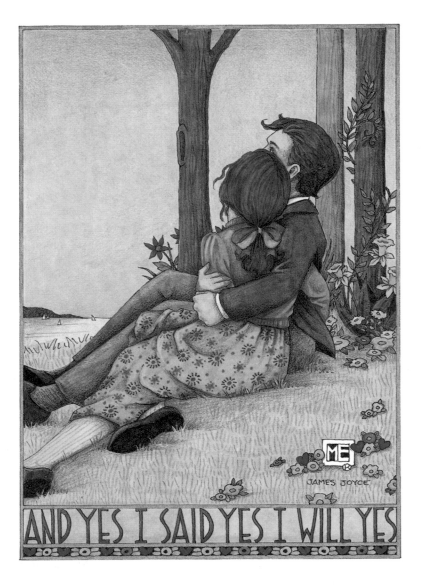

AND YES I SAID YES I WILL YES

JAMES JOYCE

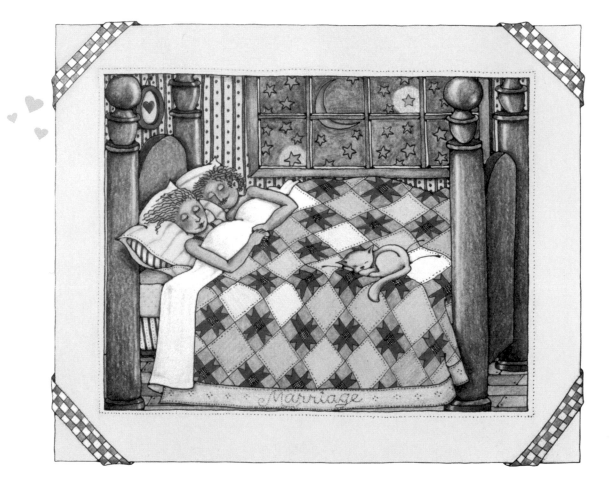

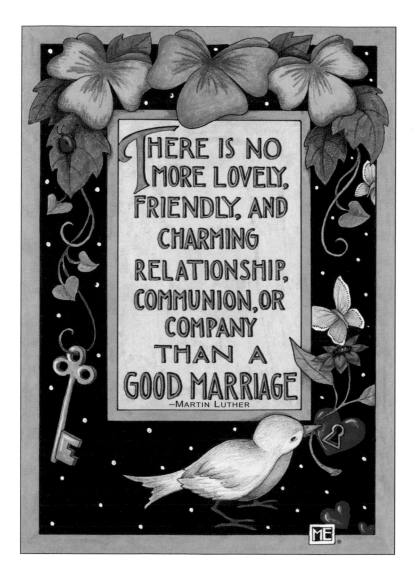

THERE IS NO MORE LOVELY, FRIENDLY, AND CHARMING RELATIONSHIP, COMMUNION, OR COMPANY THAN A GOOD MARRIAGE
—Martin Luther

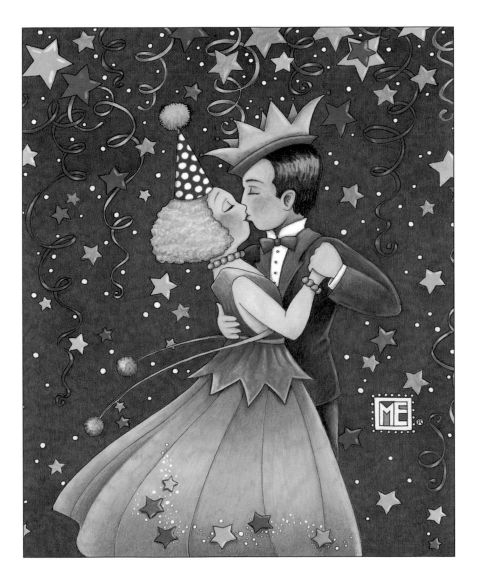

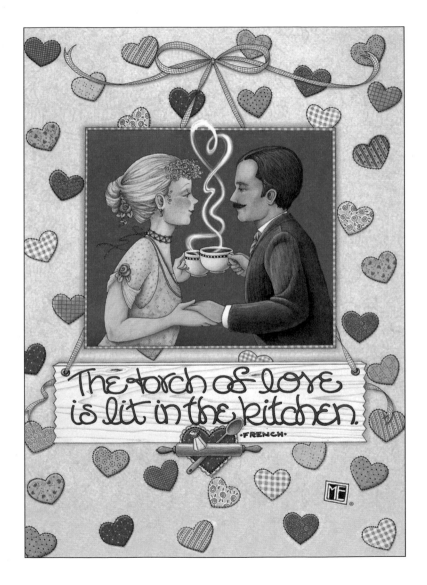

The torch of love
is lit in the kitchen.
·FRENCH·

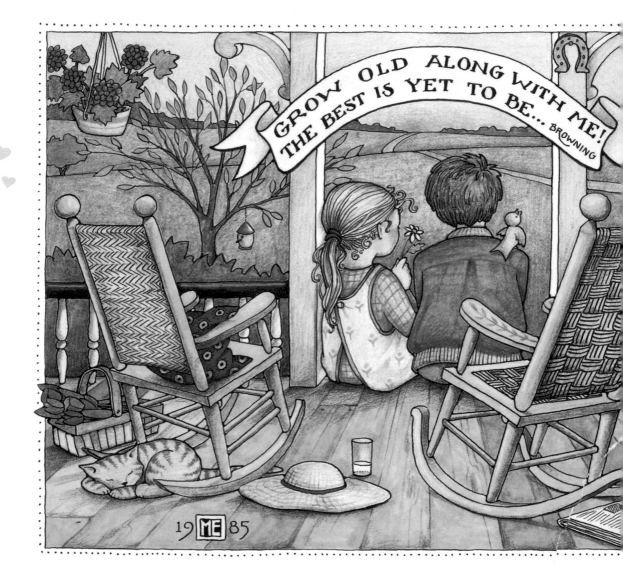

GROW OLD ALONG WITH ME!
THE BEST IS YET TO BE... BROWNING

*Life has taught us that
love does not consist
of gazing at each other
but in looking outward
in the same direction.*

—Antoine de Saint-Exupéry

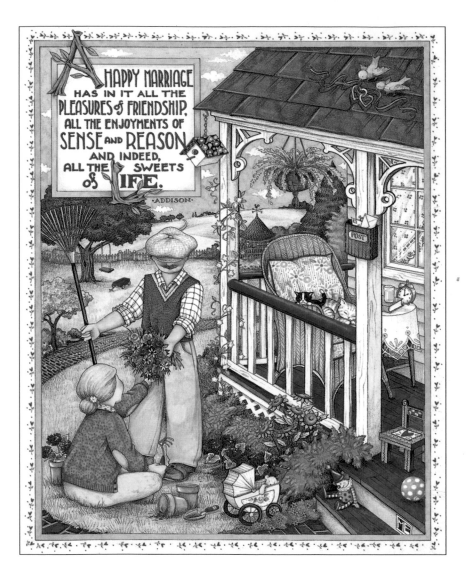

A HAPPY MARRIAGE HAS IN IT ALL THE PLEASURES OF FRIENDSHIP, ALL THE ENJOYMENTS OF SENSE AND REASON AND INDEED, ALL THE SWEETS OF LIFE.

·ADDISON·

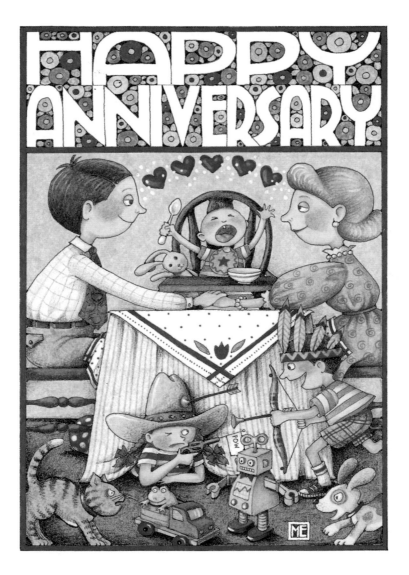

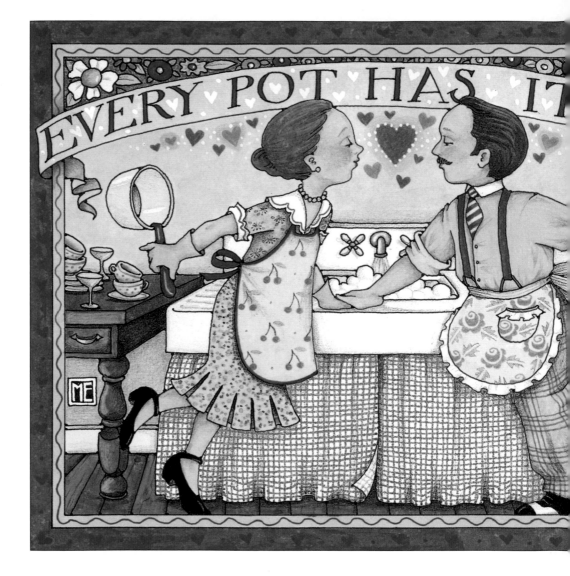

74

*Love is
but the discovery of ourselves in others,
and the delight
in the recognition.*

—Alexander Smith

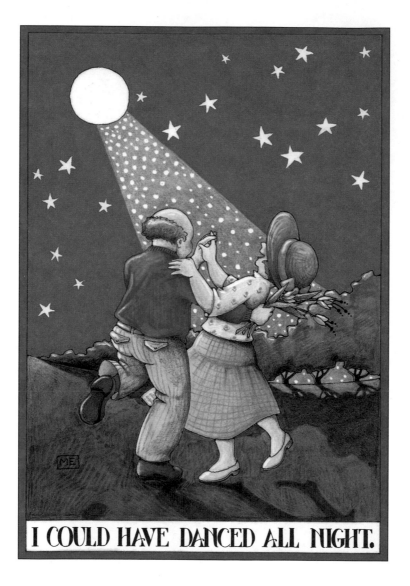

I COULD HAVE DANCED ALL NIGHT.

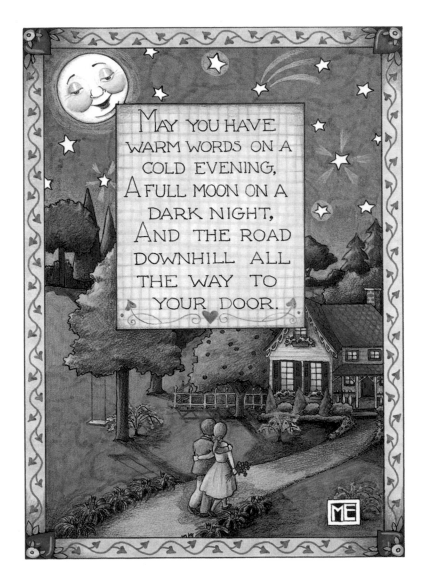

MAY YOU HAVE
WARM WORDS ON A
COLD EVENING,
A FULL MOON ON A
DARK NIGHT,
AND THE ROAD
DOWNHILL ALL
THE WAY TO
YOUR DOOR.

AND·THEY·LIVED